MODELS and PROTOTYPES

Catharina Manchanda

MODELS and PROTOTYPES

FOCUS SERIES / 1

Mildred Lane Kemper Art Museum / Washington University in St. Louis

This volume is published in conjunction with the exhibition *Models and Prototypes*, the first in the Focus Series organized by the Mildred Lane Kemper Art Museum at Washington University in St. Louis. The exhibition was held from October 25 through December 31, 2006.

Support for *Models and Prototypes* was provided by the Hortense Lewin Art Fund and individual contributors to the Mildred Lane Kemper Art Museum.

The Mildred Lane Kemper Art Museum gratefully acknowledges the lenders to the exhibition:
 Mark Bennett
 Mark Moore Gallery
 The Reykjavik Art Museum
 Nancy Reynolds and Dwyer Brown
 The Saint Louis Art Museum
 Washington University Art & Architecture Library

Published by
Mildred Lane Kemper Art Museum
Sam Fox School of Design & Visual Arts
Washington University in St. Louis
One Brookings Drive
St. Louis, Missouri 63130

Editor: Jane E. Neidhardt, St. Louis
Editorial assistant: Eileen G'Sell, St. Louis
Designer: Michael Worthington & Yasmin Khan,
Counterspace, Los Angeles
Printer: Transcontinental Litho Acme, Montréal

Library of Congress Control Number: 2006934242
ISBN: 0-936316-19-5

MILDRED LANE KEMPER ART MUSEUM
WASHINGTON UNIVERSITY IN ST. LOUIS

Cover: Edward Ruscha, *Every Building on the Sunset Strip*, 1966. Collection of the Washington University Art & Architecture Library, St. Louis. © Ed Ruscha. Courtesy Gagosian Gallery, New York.

CONTENTS

Foreword

The 2006 move of the Mildred Lane Kemper Art Museum into its new building gives us special occasion not only to celebrate the Museum's permanent collection in elegant new surroundings, but to reconsider and engage it in new ways. We are pleased to use this opportunity to inaugurate the Focus Series, which will present at least one exhibition per year that explores one or more works from the permanent collection from different interpretive frameworks, such as cultural studies, intellectual history, aesthetic theory, feminism, social history, and political history, in order to explore the complexity and multiplicity of meaning inherent in the artworks.

Focus exhibitions will challenge us to look at the collection in a constantly changing light and will be one part of a multifaceted effort to offer new perspectives and insights on the collection. The series will complement such uses of the collection as the Museum's Teaching Gallery, study room, and online collections database, as well as the planned Web-based spotlight program, in which an individual work is researched and presented to the public on a monthly basis.

Models and Prototypes, the first exhibition in the Focus Series, takes into account the vision for intellectual collaboration between the Kemper Art Museum and the Colleges of Art and Architecture, partners in Washington University's Sam Fox School of Design & Visual Arts. The exhibition examines the growing importance of conceptual and structural models within artistic practices since the early twentieth century. As the exhibition shows, models and their development into prototypes play an important role not only in art but also in architecture and design. Through this and other initiatives we hope to build upon existing scholarship while advancing our mission of exploring, exposing, and enhancing the Museum's collection from relevant contemporary perspectives.

Funding for Focus Series exhibitions is provided by the Hortense Lewin Art Fund and the generous support of individual contributors to the Mildred Lane Kemper Art Museum.

Sabine Eckmann
Director and Chief Curator

left: **Isa Genzken**, *Bill II*, 2001

Acknowledgments

Models and Prototypes considers the exploration of abstract ordering principles as methods for artistic production, the multiple in contrast to the unique work of art as a means of making and disseminating art, and the use of built structures or their schematic representation, including architectural and topographic models, in various forms of art. These kinds of models emerged as alternatives to figurative representation in the early twentieth century and enabled artists to radically reconsider artistic practice. This exhibition offers but one example of how art, architecture, and design have inspired each other during the course of the last century; its aim is to open a fruitful dialogue on which to build as we explore new territory.

My special thanks go to Director Sabine Eckmann, whose wholehearted support and thoughtful suggestions were invaluable during the development of this show. I would further like to thank Curator Robin Clark at the Saint Louis Art Museum, who discussed the exhibition with me in the early stages, and artist Katrin Sigurdardóttir for our long conversations about her work. This exhibition and catalog further benefit from Philadelphia Museum of Art Curator Michael Taylor's and architectural historian Jeannette Redensek's expert knowledge and insights into some of the finer points of Marcel Duchamp and Le Corbusier. Additional thanks go to Curator Shannon Fitzgerald, Contemporary Art Museum, St. Louis, and research librarian Jennifer Tobias, The Museum of Modern Art, New York, for providing valuable research materials.

Several key loans more fully articulate the overall concept of this exhibition and I would like to thank the artist Mark Bennett, collectors Nancy Reynolds and Dwyer Brown, Curator Thorbjorg Gunnarsdóttir at the Reykjavik Art Museum, and Molly Concannon at Mark Moore Gallery, Los Angeles, for generously making work from their collections available for this show. I am especially grateful to our colleagues at the Saint Louis Art Museum, in particular Curators Andrew Walker and Charlotte Eyerman and Director Brent Benjamin, who continue to support our exhibitions with vital loans and professional expertise.

The team effort that goes into the successful development and realization of exhibitions and publications has to be especially celebrated this fall, as four shows are installed simultaneously in a brand new building. Given the Museum's modest staff and unusually tight deadlines, this is a truly phenomenal achievement and I would like to thank the entire staff for their humor and hard work. Many thanks to our Managing Editor of Publications, Jane Neidhardt, Associate Registrar Rachel Keith, and Facilities Manager and Head Art Preparator

Jan Hessel and her dynamic staff. I would
also like to acknowledge the tireless efforts of
our students, who greatly contribute to the
success of this institution. Last but not least
I would like to thank Michael Worthington
for his elegant catalog design, Kevin Kerwin
at HKW Architects for his creative ideas
about exhibition architecture, and especially
Carmon Colangelo, dean of the Sam Fox
School of Design & Visual Arts, for his support
of this program.

Catharina Manchanda
Curator

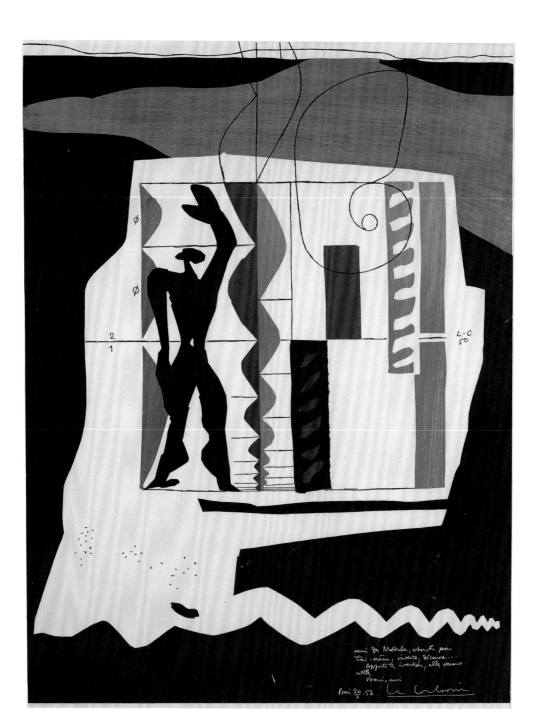

MODELS
AND PROTOTYPES

e can trace the puzzling fact that models can be either cerebral and abstract or patently concrete to the term's Latin origin, which means "small measure." Its applications are diverse, ranging from a set of plans or three-dimensional models for a future edifice, machine, or object, to a schematic design or pattern, a visualization of a theory or system, or the rendering of something that cannot be directly observed, such as an atom, or the movement of planets. In science, models are aids that help visualize, explain, or predict existing phenomena or systems. Haider A. Khan stressed these fundamental differences and noted that some scientific models, such as the globe as a model of the earth, are used as analogical devices, or simplified replicas of empirical reality, while others interpret and predict.[1]

As a preparatory step, models have also long occupied a special place in the context of artistic production. Sketches, graphs, photographs, written notes, or sculptural models were often markers of a thought process to be further developed or finalized on a larger scale or in a more permanent medium, although historically these were part of an artistic practice that centered on mimetic representation. Beginning in the twentieth century many artists turned their focus from descriptive, figurative modes of depiction to an investigation of artistic means and the ways in which paint and other materials have been used to create illusionist effects. Alternative proposals for visual representation emerged, which included constructive and deconstructive approaches. Examples of both can be found in the three related groupings that are considered in this exhibition: conceptual models, the multiple as model, and structural models.[2]

left: Le Corbusier, *Le Modulor*, 1956

1. Haider A. Khan, "On Paradigms, Theories and Model," (discussion paper, University of Denver/CIRJE; University of Tokyo, June 2002), www.e.u-tokyo.ac.jp/cirje/research/papers/khan/khan15.pdf, 5.

2. This essay is not concerned with drawing, painting, or sculpting from the human model, a studio practice that has been employed by artists since the Renaissance. While this practice remains important to this day, the models that are the focal point of this essay are used in conceptual or structural relationships, an approach that gained importance only in the twentieth century.

12

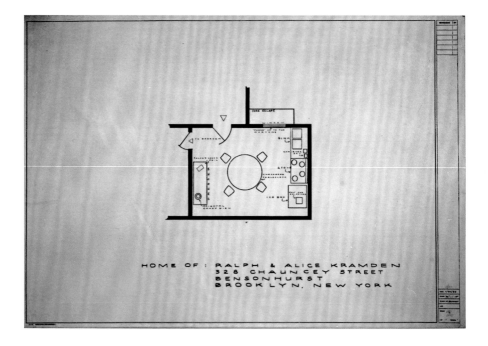

Before I go into a more detailed description of these thematic groups and the different kinds of models addressed by artists within each, it is helpful to remind ourselves that, apart from art and science, models play an integral role in all professions that entail building or construction. Some fundamental characteristics of the architectural model apply to both conceptual and structural models but are of particular relevance to the latter. The architectural model serves as a testing ground for ideas in progress. At its most innovative, it is "a site of formal and spatial experimentation where idea and design are unconstrained by technology, engineering and finance."[3] To the extent that details can be controlled, the architectural model functions as a site for projection and representation, but its relationship to a built structure is also, as this description suggests, to a considerable extent

above: **Mark Bennett**, *Home of Ralph and Alice Kramden (The Honeymooners)*, 1995

3. Jessica Morgan, "Artists Imagine Architecture," in *Artists Imagine Architecture*, exh. cat. (Boston: The Institute of Contemporary Art, 2002), 8.

fictional, containing many idealized characteristics. The same fictional and experimental characteristics can be found in the development or application of conceptual models if one understands them as systems defined by a set of rules or organizing principles.

The final design of a model can become the prototype for production. If the model implies process, the fundamental logic of the prototype is that it is the end result of a development, a structure or object that will be implemented exactly as specified. The nature of the artistic enterprise is such that artists have at times flirted with the possibility of creating prototypes, but generally within a propositional realm. Consider, for instance, Mark Bennett's fantasy of turning his architectural renderings of television stage sets into prototypes for homes. However, the actual implementation of a design on a larger, possibly mass-produced scale, it seems, would turn the artist into a designer or architect. Those artists who have come closest to implementing the logic of the prototype have done so within the realm of artistic process and tend to turn on an aspect of the readymade—such as Daniel Buren's use of an identically striped marquis pattern, which he has used consistently since the late 1960s. The appropriation of a readymade design enables him to avoid any connection with artistic craftsmanship and to draw attention to the limitation of an image's edge.

Conceptual models emerged in the context of abstraction in the early twentieth century and allowed artists to create non-mimetic works without falling in the trap of arbitrary composition. One recurring aspect of the conceptual model to which artists turned was thus an internal logic or ordering principle, as in geometry and mathematics, languages or alternative visual sign systems. Some artists used such models in playful, poetic ways—as in works by Wassily Kandinsky, Alfred Jensen, and Hannah Weiner—while others applied ordering principles in a more stringent and rigorous fashion, such as Le Corbusier, Max Bill, and On Kawara. Whether playful or rigorous, these artists used conceptual models for the purpose of construction—the creation of new pictorial or architectural constellations— while others, such as Joseph Kosuth and Jenny Holzer, examined and played with language in order to deconstruct aesthetic and social models.

The grouping of artworks that use multiples as models brings together works by artists who questioned the very concept and validity of the original work of art. This approach may be viewed as a special variant of the conceptual model, and Marcel Duchamp's critique of the original is central in this context. If Duchamp's readymades radically posited the mass-produced object as a genuine work of art in order to highlight the importance of the idea over craftsmanship and challenge established tastes and aesthetic conventions, the multiple, or editioned work, takes the lessons learned from the readymade to the next level by applying the idea of commercial production to the artwork. Conceptual and Fluxus artists of the 1960s further expanded on the use of the multiple and introduced new forms of

distribution, including direct mailing campaigns.[4] All of the works in this group are marked by playfulness and humor, and constructive and deconstructive elements often go hand in hand. The critique of the original and the development of the multiple as an artistic strategy had important consequences for artists using conceptual models and find expression in works by On Kawara, Joseph Kosuth, and Lawrence Weiner. At the same time, those who turned to structural models as a device for critique owed much to Duchamp's pioneering work with built structures, such as his *Box in a Valise* (1935–41, p. 38), a portable box containing an inventory of the artist's major works built on a model scale.

Structural models often hinge on architectural and topographic models or their representations. This group includes both alternative, or fantastic, constructs of reality, such as in the projects of Joseph Cornell and Mark Bennett, and other works that deconstruct the seamless logic of the structural model, such as those by Thomas Demand, Isa Genzken, and Katrin Sigurdardóttir. What makes deconstructive uses of structural models so complex is that they complicate the linear relationship of reality and representation. Often, they take a built structure, schematic rendering, or photograph and rupture it from within, offering the fragment as a new kind of model with which one can think about the construction of reality.

The proliferation of different types and uses of models continues unabated and suggests that they are particularly well-suited to negotiate an artistic landscape where means and methods as well as the framing conditions of art production are continuously being reconsidered and questioned. Based largely on holdings in our collection, the works in this exhibition articulate the persistent interest in conceptual and structural models from the early twentieth century to today. The three thematic groupings by which this inquiry is organized should be viewed as open-ended and interconnected; they are not intended to be complete or comprehensive. As such I would like to call upon the experimental nature of the model and ask viewers to regard *Models and Prototypes* as a proposition with the potential to be further developed, modified, and revised.

right: **Joseph Beuys**, *Noiseless Blackboard Eraser*, 1974

4. "Conceptual art" is a historically specific term that describes the work of artists in the late 1960s and 1970s who favored the elevation of a concept, proposition, or idea over the purely aesthetic or decorative object. Language, photography, and installations were often used as rhetorical anchors for an ongoing discussion about the framing conditions of art. "Conceptualism" is a term that came into circulation to describe the work of contemporary artists who take a conceptual approach. My use of the terms "Conceptual art" and "Conceptual artists" refers to the historical moment of the late 1960s. This historical reference is distinct from the working term "conceptual models," which attempts to describe certain artistic methods that have been in use from the early twentieth century until the present.

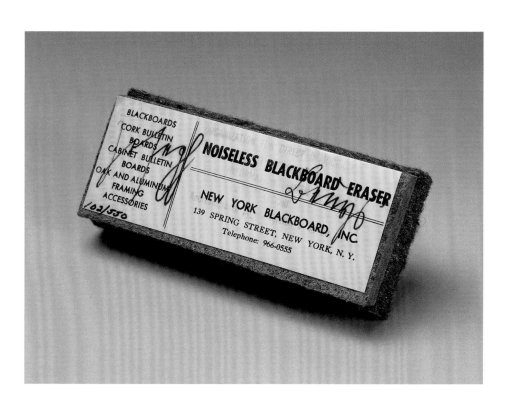

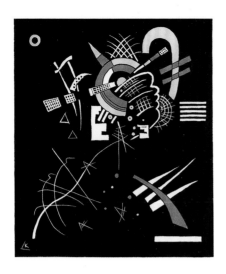
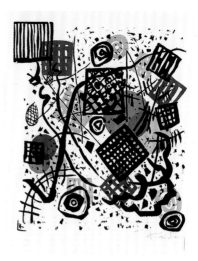
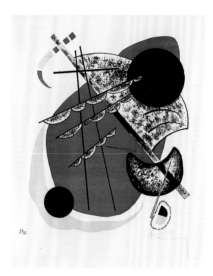

1. Conceptual Models

One of the first significant shifts in early twentieth-century art was the exploration of non-representational visual language systems that challenge long-held assumptions about the role of art. These experiments led artists on a path towards abstraction and radically redefined artistic objectives, particularly in painting, drawing, and printmaking. A recurring theme in the first decades of the century was a search for models that facilitated the creation of harmonious composition as an alternative to figurative representation. In this pursuit, geometric forms and mathematical sequences gained importance because they offered a logical structure as a point of departure. Non-objective composition was not merely an aesthetic choice but held the promise of creating poetic and transcendental meaning. Wassily Kandinsky's 1922 print series *Kleine Welten* (*Small Worlds*) is a case in point. It was one of his first compositions to introduce abstract and geometric forms in space and move away from the strong landscape allusions that had dominated his work in the 1910s. By titling the portfolio *Small Worlds*, Kandinsky marked the pictorial space as something removed from the "real" world. The artist's ideas about non-objective representation had evolved over a period of more than a decade following his programmatic publication *On the Spiritual in Art* (*Über das Geistige in der Kunst*) of 1911. In this he linked visual expressions of an inner, immaterial world with a search for rhythmic, abstract mathematic construction.[5] His declared aim was to create visual relationships between colored forms that were comparable to contemporary music theory, such as Arnold Schönberg's twelve-note serial method, which he greatly admired. This theory of form

left: **Wassily Kandinsky**, six selections from the *Kleine Welten* (*Small Worlds*) series, 1922

5. See Wassily Kandinsky, *Über das Geistige in der Kunst*, 10th ed. with an introduction by Max Bill (Bern: Bentli Verlag, 1952), 55. The portfolio was made when the artist began teaching at the Bauhaus, an institution that defined itself as an interdisciplinary research laboratory with the ambition to turn avant-garde designs into prototypes for mass production.

and color was an attempt to rationalize a set of rules that were imbued with a theosophist-inspired spirituality and was meant to invite a contemplative experience over time, much like a musical performance. For Kandinsky and his contemporary viewers, the *Small Worlds* portfolio could serve a model function, as its title indicates, for an ongoing experiment in the creation of a fictional pictorial universe.

French artist and architect Le Corbusier was also concerned with questions of harmony. He worked nearly a decade on a mathematically-based measuring tool, *The Modulor* (p. 10), which he hoped would function as a model for creating harmonious proportional relationships. First published in French in 1948, *The Modulor* was a theoretical treatise written and illustrated by Le Corbusier in which he reconsidered a familiar topic: the proportions of the human body in relation to architectural scale and structure.[6] Le Corbusier's measuring system was founded on geometric relationships of the square and the double square and was modified by two scales—which he termed the red series and the blue series—derived in part from Leonardo Fibonacci's interpretations of the Golden Section.[7] Le Corbusier's 1956 lithograph illustrates some of the key relationships in his system. The publication was ambitious, for he intended *The Modulor* to become a universal standard that would be used for the construction of buildings as well as the mass production and distribution of goods. Although ostensibly mathematical in design, Le Corbusier's treatise is at times idiosyncratic, starting with the measure of a man six feet tall on which the entire system was based. Contrary to his overall objective, the application of his measures could serve as a guide but did not necessarily guarantee a harmonious outcome; Corbusier himself adapted the model whenever necessary to suit his needs. Art historian Rudolf Wittkower observed that his theories were at once "amateurish, dynamic, personal, paradoxical, and often obscure" and saw in them the expression of a poetic mind, rather than an objective and practical tool.[8]

right: **Alfred Jensen**, *Great Mystery I* [Chinese Origin of the Decimal System! External Placement.] 1960

6. The first edition to appear in English was in 1954. See Le Corbusier, *The Modulor: A Harmonious Measure to the Human Scale Universally Applicable to Architecture and Mechanics*, trans. Peter de Francia and Anna Bostock (Cambridge, MA: Harvard University Press, 1954).

7. Ancient Greek ideas about proportion and scale had been reevaluated and applied during the Middle Ages (based on Platonic models) and the Renaissance (in a return to ancient anthropometry). Le Corbusier sought an application for modern architecture, production, and trade. The Golden Section is a ratio that dates back to the Pythagoreans: "In mathematics, [it is] a division of a line segment into two sections such that the ratio of the original segment to the larger division is equal to the ratio of the larger division to the smaller division.... The numerical ratio of the greater segment of the line to the shorter segment as determined by the Golden Section is symbolized by the Greek letter phi.... It occurs in many widely varying areas of mathematics. For example, in the Fibonacci sequence (the sequence of numbers formed by adding successive members to find the next member—0,1,1,2,3,5,8,13...), the values of the ratios...approach the value of the Golden Section." (*The Columbia Encyclopedia*, 6th ed. online, 2001–2005, http://www.bartleby.com/65/go/GoldenSe.html, cited August 25, 2006).

8. Rudolf Wittkower, "Le Corbusier's Modulor," in *Four Great Makers of Modern Architecture: Gropius, Le Corbusier, Mies van der Rohe, Wright* (New York: Da Capo Press, 1970), 203.

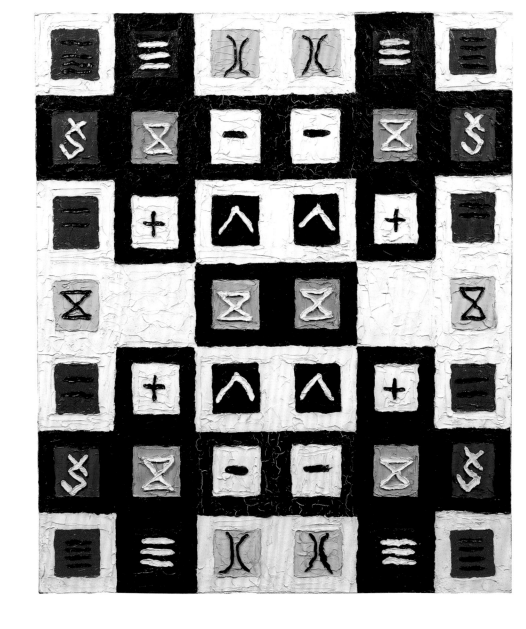

While subjective and paradoxical aspects in Le Corbusier's proportional model lurk behind a veneer of mathematic objectivity, the artist Alfred Jensen appropriated and reinterpreted some of the most universalizing and abstract ancient numerical systems. Wittkower's preface to his discussion of Le Corbusier's *The Modulor* is equally appropriate when considering Jensen's work:

20

> So far as I can see, the belief in an order, divine and human, derived from numbers and relations of numbers was always tied to higher civilizations. It must be regarded as one of the most extraordinary events in the early history of mankind when a bridge was created between abstract mathematical thought and the phenomenal world that surrounds us; when geometry and numbers were found to govern the skies as well as all creation on earth.[9]

This precisely seemed the point of departure for Jensen, who correlated ancient Chinese, Pythagorean, and Mayan numerical systems with temporal or geographic indicators such as calendars, sun dials, compasses, footprints or profiles of ancient architecture, and color systems. *Great Mystery I* [Chinese Origin of the Decimal System! External Placement.] from 1960 is a good example of one systemic model feeding into another. The painting is composed of four Lo Shu diagrams, the oldest known example of a magic square, using figures one through nine, written in ancient Chinese characters, in a three-by-three grid in such combinations that the sum of each vertical, horizontal, and diagonal line adds up to fifteen:

$$
\begin{array}{ccc}
4 & 3 & 8 \\
9 & 5 & 1 \\
2 & 7 & 6
\end{array}
$$

"My use of numbers," Jensen wrote, "is governed by the duality and opposition of odd and even number structures," and in *Great Mystery I* he highlights the complementing harmony of opposites that were part and parcel of ancient Chinese philosophy.[10] The origin of the Lo Shu diagram was considered divine. The odd numbers were thought to be heavenly, the even ones earthly, and each individual number had a variety of designations, including one for color. Although Jensen copied the ancient Chinese characters into his painting, he departs from the Chinese model with regard to color designation. The precise meaning of his color scheme remains elusive. Odd and even numbers are placed on white and black backgrounds, respectively. He grouped even numbers with hues from the warm color spectrum

9. Ibid., 197.

10. Alfred Jensen, "The Prism Machine," http://www.alfredjensen.com (cited August 25, 2006).

and odd ones with the cool colors. An exception is the figure five, located at the center of the Lo Shu diagram and the average value for each field, which he placed on a grey background. As a mixture of black and white, the grey seems to reflect the special significance of the number five in the diagram. Since few Western viewers are conversant in ancient Chinese letters, it is the symmetry and repetition in Jensen's painting that are most striking and express the visual equivalent of the numeric harmonies of the diagram. Whereas the Lo Shu configuration was understood to contain intricate implications in ancient Chinese society for governance, philosophy, and everyday life, Jensen chose to highlight its aesthetic potential. Presented like a riddle, *Great Mystery I* challenges the viewer to probe the diagram's mysteries on various visual and conceptual levels.

A preoccupation with harmonious relationships also defines the work of Swiss artist, architect, and designer Max Bill. Educated at the Bauhaus in Dessau where he studied with Paul Klee between 1927 and 1929, Bill's subsequent career can be viewed as an embodiment of Bauhaus principles in as much as he moved fluidly between painting, sculpture, architecture, typography, product design, and writing. As an artist, Bill viewed himself as a proponent of "concrete" rather than abstract art:

> We call Concrete Art those works of art which originate on the basis of means and laws of their own, without external reliance on natural phenomena or any transformation of them, in other words without undergoing a process of abstraction. Concrete painting and sculpture are the formulation of what is optically perceptible. Their means of formulation are colours, space, light and movement. ... Concrete Art in its ultimate outcome is the pure expression of harmonic laws and proportions.[11]

Given his interest in structural relationships, modular sequences, and serial systems, as well as form and color, it is hardly surprising that Bill wrote introductions for key publications on both Kandinsky and Le Corbusier.[12] Pondering the future possibilities of contemporary art in 1949, Bill called for an approach to art comparable to mathematics—a creation of component parts within larger geometric forms or sequences that would appeal to both logos and feeling. The legacy of Klee's and Kandinsky's Bauhaus teachings is crucial to an understanding of Bill's work, for beyond its play with formal relationships lies a higher, symbolic purpose, an attempt to visualize infinite systems within a finite form. His *16 Constellations* (1974) grew out of concepts he developed in the 1940s, which he revised and modified in subsequent decades. It is a visual sequence that the artist devised following

11. Max Bill, "Konkrete Gestaltung," originally published in *Zeitprobleme in der Schweizer Malerei und Plastik*, exh. cat. (Zürich: Kunsthaus, 1936); as quoted in Margit Staber, *Artists of Our Time*, vol. XIV, *Max Bill* (St. Gallen: Erker-Verlag, 1971), 23.

12. See Max Bill, "Einführung," in Wassily Kandinsky, *Über das Geistige in der Kunst* (Bern: Bentli Verlag, 1952), 5–16, and Max Bill, "Introduction," in *Le Corbusier and P. Jeanneret: Oeuvre Complète, 1934–1938*, 2nd ed. (Zürich: H. Girsberger, 1945).

a set of self-imposed rules, which are detailed in the artist's statement accompanying the prints.[13] Within the chromatic color scale three geometric shapes, a circle, a semicircle, and a quarter circle, are sequentially arranged into sixteen progressive constellations. As the viewer moves from one image to the next the configurations move in circular fashion like the fingers of a clock. Bill's directives were rigorous:

The constellation of the groups is governed by the following rules

1. the circle does not move

2. the lines never intersect

3. the same constellation is not allowed to repeat itself by symmetrical reflection

4. both the semicircle and the quarter of a circle are oriented by a rectangular system in which the position of the three lines in relation to each other changes by 90 degrees or a multiple of this

Bill's sequence thus illustrates one interpretation of the model as a system governed by predetermined rules as well as the artist's conviction that his works were "models for contemplation and reflection."[14]

In the context of the 1960s, one finds different applications of the kind of sequential models that Bill developed. Minimal and Conceptual artists largely rejected, however, meditative, transcendental, utopian ideals as well as the concept of originality as located in artistic craftsmanship. Some of the core definitions of Conceptual strategies were formulated by practitioners of Minimalism, who had utilized industrial materials, serial processes, and installations beginning in the early 1960s. Minimalists began to map the relationship between structures and the surrounding gallery space and make the viewer a key player in a different kind of perceptual experience. The individual and the artwork were no longer considered separate entities, but part of a seamless, spatial fabric. In a parallel step, a number of artists also shifted their focus from the production of objects or environments to what might be termed the preparatory stage, exploring the extent to which the concept or idea could become the *a priori* model. Following this thought to its logical conclusion, the final object or installation could be considered an implementation, to be executed by assistants or hired craftsmen, rather than the artist. The idea became valued as equal to the actual execution—a radical thought that found perhaps its quintessential expression in Lawrence

right: Max Bill, *16 Constellations*, 1974

overleaf: Joseph Kosuth, *Four Titled Abstracts*, from No. 3 of the *SMS Portfolio*, 1968

13. Max Bill, "Artist's Statement" included in the portfolio *16 Constellations* (1974). Bill describes in the statement how the idea for this portfolio "was first carried out in a painting of 1944 that was made up of three circular curves. This was the beginning of my research into problems related to the vibration that takes place on the edges of colour."

14. Max Bill, as quoted in Michele Emmer, "Visual Mathematics: Mathematics and Art," in *The Visual Mind II*, ed. Michele Emmer (Cambridge, MA: MIT Press, 2005), 78.

24

ăb′străct¹, a. Separated from matter, practice, or particular examples, not concrete; ideal, not practical; abstruse; (with *the*, as noun) the ideal or theoretical way of regarding things (*in the* ~). Hence ~LY² adv., ~NESS n. [ME. f. L *abstractus* p.p. of ABS(*trahere* draw)]

ab·stract (ab-strakt′, ab′strakt), *adj.* [L. *abstractus*, pp. of *abstrahere*, to draw from, separate; *ab*(*s*)-, from + *trahere*, to draw], 1. thought of apart from any particular instances or material objects; not concrete. 2. expressing a quality thought of apart from any particular or material object: as, beauty is an *abstract* word. 3. not easy to understand; abstruse; hence, 4. loosely, theoretical; not practical. 5. in *art*, characterized by design or form that is geometric or otherwise not representational. *n.* (ab′strakt), 1. a brief statement of the essential thoughts of a book, article, speech, court record, etc.; summary. 2. that which is abstract: as, the *abstract* fascinates his mind. Abbreviated **abs.** *v.t.* (ab-strakt′), 1. to take away; remove. 2. to think of (a quality) apart from any particular instance or material object that has it; form (a general idea) from particular instances. 3. (ab′-strakt), to summarize; make an abstract of. —*SYN.* see **abridgment.**
in the abstract, in theory as apart from practice.

ab'stract, 1 ab'strakt, 2 ăb'străct, *a.* **1.** Produced by or resulting from abstraction: applied to an idea or mental image when deprived of most of its individual features; having the nature of a conception or general notion. Man and human are concrete; humanity is an *abstract* notion. Porter *Intellectual Science* pt. iii, ch. 2, p. 332. [s. 1871.] **2.** Viewed apart from concrete form, individual example, or actual practise: said of numbers, attributes, qualities, etc.; general, as opposed to particular; theoretical, as opposed to practical. The teachings of Christ are not *abstract* doctrines. A. P. Stanley in *Thoughts that Breathe* ccliii, p. 285. [D. L. CO. 1879.] **3.** Withdrawn from contemplation of present objects; abstracted; as, he had an *abstract* air. **4.** Ideal; imaginary; visionary; as, *abstract* piety: opposed to *real, practical, rational.* **5.** Hard for the mind to grasp; abstruse; metaphysical; as, *abstract* speculations. a popular use. **6†.** Separate; drawn or taken away (from). [< L. *abstractus,* pp. of *abstraho,* < *abs,* from, + *traho,* draw.]

25

¹**ab·stract** \(')abz¦trakt, əbz'-, -ab¦st-, əb'st-\ *adj, sometimes* -ER/-EST [ME, fr. L *abstractus,* past part. of *abstrahere* to draw away, withdraw, fr. *abs-* (var. of *ab-* ¹ab-) + *trahere* to pull, draw — more at TRACE] **1** *archaic* : absent in mind : ABSTRACTED **3** ⟨~, as in a trance —John Milton⟩ **2** [ML *abstractus,* fr. L, past part.] **a** : considered apart from any application to a particular object or specific instance : separated from embodiment ⟨an ~ entity⟩ ⟨arguments from ~ probability —P.E.More⟩ **b** : difficult to understand : ABSTRUSE ⟨more ~ problems involving judgment and ability to reason —*Saturday Rev.*⟩ **c** : IDEAL ⟨to shed tears over ~ justice and generosity . . . and never to know these qualities when you meet them in the street —William James⟩ **d** : insufficiently factual : FORMAL ⟨she possessed all civil rights — but these were ~ and empty —H.M.Parshley⟩ ⟨~ and doctrinaire instruction⟩ **e** *of a unit or number* : having no reference to a thing or things — opposed to *concrete* **3** *archaic* : drawn away : REMOVED, SEPARATE **4** : expressing a property, quality, attribute, or relation viewed apart from the other characteristics inhering in or constituting an object ⟨*honesty, whiteness, triangularity* are ~ words⟩ **5** : dealing or tending to deal with a subject in the abstract: as **a** *of a science* : PURE, THEORETICAL — contrasted with *applied* **b** : IMPERSONAL, DETACHED ⟨I should have remained mainly academic and ~ but for the war —Bertrand Russell⟩ ⟨the ~ compassion of a surgeon —*Time*⟩

STRING STRING STRING STRING STRING STRING STRING
STRING turf STRING STRING turf STRING STRING turf STRING STRING turf STRING STRING turf STRING STRING turf STRING STRING turf STRING
STRING STRING STRING STRING STRING STRING STRING

STRING STRING STRING STRING STRING STRING STRING
STRING turf STRING STRING turf STRING STRING turf STRING STRING turf STRING STRING turf STRING STRING turf STRING STRING turf STRING
STRING STRING STRING STRING STRING STRING STRING

STRING STRING STRING STRING STRING STRING STRING
STRING turf STRING STRING turf STRING STRING turf STRING STRING turf STRING STRING turf STRING STRING turf STRING STRING turf STRING
STRING STRING STRING STRING STRING STRING STRING

STRING STRING STRING STRING STRING STRING STRING
STRING turf STRING STRING turf STRING STRING turf STRING STRING turf STRING STRING turf STRING STRING turf STRING STRING turf STRING
STRING STRING STRING STRING STRING STRING STRING

STRING STRING STRING STRING STRING STRING STRING
STRING turf STRING STRING turf STRING STRING turf STRING STRING turf STRING STRING turf STRING STRING turf STRING STRING turf STRING
STRING STRING STRING STRING STRING STRING STRING

STRING STRING STRING STRING STRING STRING STRING
STRING turf STRING STRING turf STRING STRING turf STRING STRING turf STRING STRING turf STRING STRING turf STRING STRING turf STRING
STRING STRING STRING STRING STRING STRING STRING

STRING STRING STRING STRING STRING STRING STRING
STRING turf STRING STRING turf STRING STRING turf STRING STRING turf STRING STRING TURF STRING STRING TURF STRING STRING TURF STRING
STRING STRING STRING STRING STRING STRING STRING

STRING STRING STRING STRING STRING STRING STRING
STRING TURF STRING STRING TURF STRING STRING TURF STRING STRING TURF STRING STRING TURF STRING STRING TURF STRING STRING TURF STRING
STRING STRING STRING STRING STRING STRING STRING

STRING STRING STRING STRING STRING STRING STRING
STRING TURF STRING STRING TURF STRING STRING TURF STRING STRING TURF STRING STRING TURF STRING STRING TURF STRING STRING TURF STRING
STRING STRING STRING STRING STRING STRING STRING

STRING STRING STRING STRING STRING STRING
STRING TURF STRING STRING TURF STRING STRING TURF STRING STRING TURF STRING STRING TURF STRING STRING TURF STRING
STRING STRING STRING STRING STRING STRING

Weiner's 1968-69 "Statement of Intent," which accompanied his subsequent works:

The artist may construct the piece

The piece may be fabricated

The piece need not be built

Each being equal and consistent with the intent of the artist, the decision as to condition rests with the receiver upon the occasion of receivership [15]

Weiner's *Turf, Stake and String* of 1968 is situated at the intersection between idea and execution; the artist "visualized" an installation by mapping the envisioned arrangement with the repetitive placement of the words "turf," "stake," "string," the materials with which the installation would be built. Printed on a self-adhesive vinyl sheet, the diagram could be adhered to a wall and displayed like an art object. At the same time, the piece functions as a conceptual model; its implementation is left to the imagination and can take any number of forms, since scale, location, and other details are left unspecified.

While Lawrence Weiner was increasingly content to see the work exist solely as a written proposition, Joseph Kosuth, another key conceptual artist, went a step further and made the discourse on art—the parameters that delineate artistic practices and their scholarly analysis—form the center of his artistic enterprise. *Four Titled Abstracts* (1968), a simple juxtaposition of four different dictionary definitions of the term "abstract," illustrates this interest in the meta-language of art and art history, in the terms and definitions that frame theoretical discussions.[16] Many other works, often humorous, poetic, and visually compelling, also evidence the growing attention to language and alternative sign systems that began at this time. For her *Signal Flag Poems* (1968), Conceptual artist and poet Hannah Weiner turned to the international communication system for ships at sea to create visual poems that were juxtaposed to the written version, prompting the reader to consider the relation between form and content. The beauty of the nautical sign system, for Weiner, was the fact that the flag sequences would register for most viewers, not on a functional or narrative level, but on a purely visual, aesthetic one. The suggestive power of Weiner's piece stems from the fact that she applied a specialized visual sign system to a new context and in so doing brought attention to the way systemic models can be used to create new meanings. Designed for utilitarian communication, the nautical sign system's geometric shapes become here the means for aesthetic and poetic expression.

left: **Lawrence Weiner**, *Turf, Stake and String*, from No. 5 of the *SMS Portfolio*, 1968

15. Lawrence Weiner, "Statement of Intent," reprinted in Alexander Alberro, *Conceptual Art and the Politics of Publicity* (Cambridge, MA: MIT Press, 2003), 97.

16. Joseph Kosuth's interest in the conceptual underpinnings of art production was an important component within the diverse field of conceptual experimentation, but it is sometimes misleadingly posited as the quintessential characteristic of Conceptual art. While Kosuth's practice led him to examine and critique existing ideas and definitions concerning art and aesthetics, other approaches focused on the methods of making a work of art following written directives. Sol LeWitt stressed the importance of visualizing a system or proposition and singled out modular methods as a successful strategy. See Sol LeWitt, "Paragraphs on Conceptual Art," *Artforum* 5, no. 10 (June 1967): 79–84.

These poems are taken from the International Code of Signals for the Use of All Nations, editions 1857, 1899 and 1931. This is a visual signal system for ships at sea. Single and 2 flag hoists are distress signals, 3 flag hoists are general signals. In addition each flag has a name: A, Alfa; B, Bravo; R, Romeo; J, Juliet.

Hannah Weiner

RPJ Want Men

RJE	man
DWS	alderman
GVL	boatman
IFD	cattleman
TUO	chairman
ITX	clergyman, parson or minister
MDK	have you men enough?
NAB	fireman
NBS	fisherman
NJX	foreman
OTR	helmsman
RKI	how many men?
QIB	landsman
QJL	leadsman
QPJ	liberty man
RAE	look-out man look out!
NSX	he, or she is full of men
RPH	newly raised man
SIT	nobleman
TQO	postman
UXF	rifleman
VLG	seaman
WDH	signalman
YZM	tradesman
YWH	waterman
ZIA	workman
MDK	have you men enough?
RPJ	want men
RPK	your men

Hannah Weiner, *Signal Flag Poems*, from No. 3 of the *SMS Portfolio*, 1968

In the 1960s, the urban environment became a favorite site for institutional and social critiques. Operating at the intersection of Minimalist and Conceptual sensibilities, French artist Daniel Buren used a readymade striped marquis fabric and installed it in different locations. Instead of creating a unique object, he makes his mark through the placement of a repetitive and recognizable pattern. Although color and material have varied considerably, his pattern has remained consistent and operates as a prototype that can be endlessly duplicated. Some of his earliest interventions included installations of this serial pattern on billboards in the Paris subway, city buses, building façades, and other urban contexts. The striped design has been produced as posters, flags, garments, and enameled steel plates and can be placed in different horizontal or vertical configurations, but always equidistant from each other. In all its applications the serial pattern emphasizes the limitation of the edge—the surrounding wall, gallery, or building—through its capacity to be, theoretically, infinitely expandable, like a grid.[17] As a serial arrangement it functions essentially as a mapping system that allows the artist to visually connect incongruous spaces. In these ways Buren's work has both a spatial and a temporal component. To this day, each new installation is a continuation of the original idea; it thereby creates a relationship between structures and places all over the world and connects the art gallery and museum to the street and to a larger social, economic, political, and cultural fabric.

Likewise, On Kawara chose a single system as the model for his artistic practice. Informed by a Minimalist sensibility, he visualized the passage of time in ever-new permutations. For his multiple *100 Year Calendar* (1968), Kawara mapped the temporal expanse of one hundred years on a single sheet of paper. The representation of time is here compressed month by month, year by year, into a grid system, theoretically expandable into the past as well as the future. Although overall stringent, the system of the grid undergoes subtle variation in the month of February, as each leap year is a reminder that the Western calendar is an approximation. The calendar gives visual expression to an expanse of time, a method often used by the artist, but he also conceived of paintings and postcard series that were built around one task or one event in the context of a single day. The monochrome paintings of his *Today Series* (p. 34), which he began in 1966, simply depict the date the work was made. The specifics of time and place are significant, for each painting comes with a cardboard box that contains a newspaper clipping published in the same city and on the same day. The result of a repetitive work process and uniform in appearance, the paintings surreptitiously refer to the kaleidoscopic nature of daily events through the daily news events housed in their container. Kawara draws attention to the incongruity between the

right: **On Kawara**, *100 Year Calendar*, from No. 4 of the *SMS Portfolio* (detail), 1968
overleaf: **Daniel Buren**, *Twenty-five Enamel Plates*, 1993

17. Rosalind Krauss's summary of the grid's appeal helps to bring Buren's project into focus: "the grid extends, in all directions, to infinity. Any boundaries imposed upon it by a given painting or sculpture can only be seen according to this logic as arbitrary. By virtue of the grid, the given work of art is presented as a mere fragment, a tiny piece arbitrarily cropped from an infinitely larger fabric." Rosalind E. Krauss, "Grids," in *The Originality of the Avant-Garde and Other Modernist Myths*, 6th ed. (Cambridge, MA: MIT Press, 1989), 18.

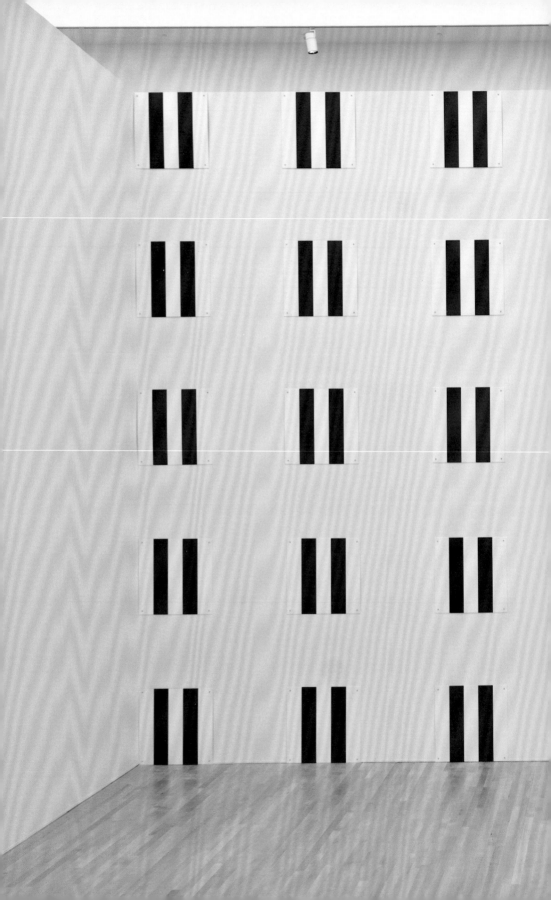

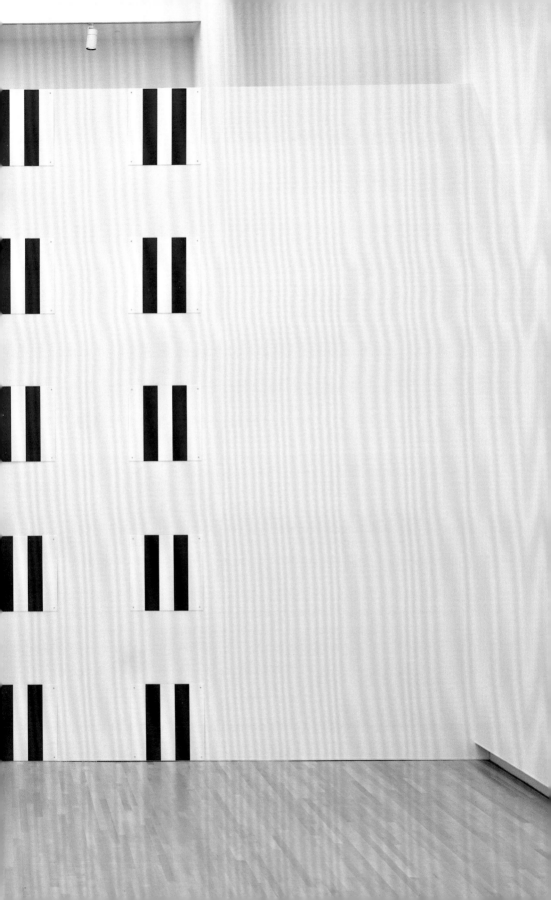

DEC.14,2004

static and factual representation of a date and the innumerable events that take place in a single day or, by implication, a single year or century. Some days may be significant political or historical dates, filled with events reported in the news; others may be less politically significant but may have private resonance for the artist or the viewer.[18]

Jenny Holzer's work revolves around a critique of the enduring invisible codes and slogans, social models, and stereotypes that serve as points of reference in everyday life. Her work operates first and foremost in the public domain, and she has acknowledged Daniel Buren's urban installations as an important point of reference. It is equally helpful to consider her work in relation to Joseph Kosuth's dictionary definitions, because the problems grow far more complex when one shifts from the examination of the gaps that open when comparing different explanations of the same term to a focus on statements that operate obliquely between off-the-cuff-remark and proverb. Holzer's first text-based interventions were her *Truisms* (1977–79), which she printed on posters and anonymously posted in different locations in New York City. Other modes of circulating her statements have included stickers, plaques, bench signs, electronic signboards, projections, movie announcement boards, television, and Internet websites—in short, the same means through which advertisements, political or religious slogans, social codes, and stereotypes are disseminated. Holzer stages the authoritative power of the succinct declaration; their placement provides a further rhetorical frame, as in the appearance of "MONEY CREATES TASTE" on a billboard in Las Vegas. Ann Goldstein noted that Holzer's pointed messages "absorb and emulate a variety of viewpoints, both masculine and feminine, across the political spectrum…; each truism is a design for living, and collectively they are a manifesto saturated through the landscape."[19]

18. In On Kawara's *100 Year Calendar*, it is interesting to note that through slightly thicker lines the work draws subtle attention to the year 1968—the year the piece was produced and distributed as part of the *SMS Portfolio* (see the discussion of the work of William Copley following in section 2: The Multiple as Model).

19. Ann Goldstein, "Baim-Williams," in *A Forest of Signs: Art in the Crisis of Representation*, exh. cat., ed. Catherine Gudis (Cambridge, MA: MIT Press; Los Angeles: Museum of Contemporary Art, 1989), 34. The exhibition was organized by Ann Goldstein and Mary Jane Jacob.

If many of Holzer's early installations allowed the viewer to see a statement at one glance, her LED displays introduce a temporal element and mirror the streams of electronic news-flashes and stock values on display in places such as Times Square, where architectural space seems liquefied by the competing projection screens. The artist has often used the LED format for museum installations, since this is a place where people are more willing to spend more time looking at a work.[20] Without the commercial competition of urban street signage, the scrolling statements provoke the viewer to engage and debate their meanings. The messages in Holzer's *Survival Series*, conceived in the early 1980s, take the form of an urgent appeal or demand, as in "PROTECT ME FROM WHAT I WANT," and her LED screen is just one way in which the statements can be disseminated. Although Holzer's declarations come in a familiar form (both linguistically and in terms of presentation), they often rub against established stereotypes, and here they become most productive.[21] Especially when presented with a list of contradictory statements, as in her *Survival Series*, her critique of social stereotypes that serve a model function in everyday life is patently evident. Despite her deconstructive approach, Holzer seems to hold on to the possibility of effecting change, if not through immediate recognition then through the repetitive dissemination of her own declarations, the most resonant of which have already entered our stock of references and become models of a different kind.

left: **On Kawara**, *Dec. 14, 2004*, 2004, from the *Today Series*, 1966–
above: **Jenny Holzer**, *Selections from "The Survival Series,"* 1983–84

20. See the interview with Jenny Holzer, "Jenny Holzer: Space, Language & Time," reprinted in *New Art: An International Survey*, ed. Andreas Papadakis, Clare Farrow, and Nicola Hodges (New York: Rizzoli, 1991), 171.

21. "MEN DON'T PROTECT YOU ANYMORE" (also printed on condoms) is but one example of how the stereotypical image of men as heroic protectors, established through countless novels, movies, and advertisements, can be successfully questioned.

Marcel Duchamp was an avid chess player, and the game could be considered a key conceptual model through which he looked at his artistic practice. One finds in his work the first instance of a reevaluation of aesthetic and cultural models through the use of built structures. Over the course of his career, he frequently combined this critique of theoretical models with formal solutions that incorporated structural models, specifically the use of box containers and miniature displays stocked with identical replicas of his signature works. Duchamp's method of building structural models for the purpose of deconstructing less tangible theoretical models might be considered quintessentially conceptual: the artist presents the viewer with an object that looks patently straightforward but poses as a camouflage or decoy in order to reach other objectives. His famous editioned boxes, *Box in a Valise* (1935–41) and *Green Box* (1934),[22] were concerned with the notion of original and copy. The former first appeared as an edition of twenty in 1941 and was followed by the production of other editions over more than two decades; it contains some of Duchamp's most important works, including several readymades, most built on a model scale. This box was both container and display case and reversed the traditional artistic sequence of a preparatory model, or prototype, followed by a final work. To further insult the fetishistic tendencies of art professionals and collectors focused on "the original," both *Box in a Valise* and *Green Box* existed as multiples. In *mis-en-abyme* fashion, the *Green Box* contains notes and preparatory sketches pertaining to Duchamp's famous installation *The Bride Stripped Bare by Her Bachelors, Even*, a work that is a tongue-in-cheek schematic

left: Marcel Duchamp, *Pocket Chess Set*, 1944

22. *Green Box* is the object's nickname, which is derived from the box's cover. The official title is *La mariée mise* à *nu par ses célibataires, même* (*The Bride Stripped Bare by Her Bachelors, Even*), which is the same title as Duchamp's glass panel installation of 1915–23, also known as the *Large Glass*.

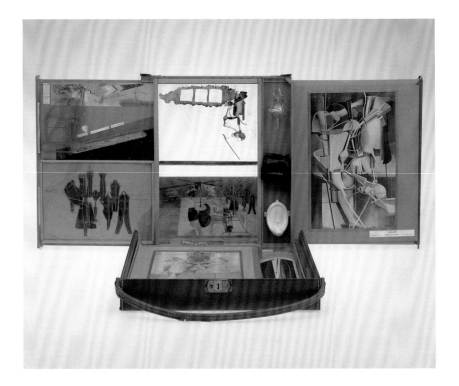

model of a thoroughly elusive process: the endless, almost mechanical (and often futile) pursuit of sexual desire. The set of notes in each editioned *Green Box* consists of facsimiles of Duchamp's original scribbled notes, to the point where every torn scrap of paper was meticulously recreated. In addition, the twenty issues of the box's "deluxe edition" include one original document each, thus further blurring the line between original and copy.[23] The serial nature of the boxes fundamentally questions the concept of the original artwork, and the contents deconstruct the archival focus on the original document. Instead of the model as a point of origin, Duchamp makes it the destination. He effectively employed the multiple as model for artistic production, which seems perfectly appropriate when considering that his main objective was the circulation of ideas. His portable *Pocket Chess Set* (1944), issued in an edition of twenty-five, complements his two boxes, for it not only attests to his lifelong fascination with the game but obliquely articulates his approach to art as a playing field, the rules of which he continuously aimed to redefine on his own terms.

above: **Marcel Duchamp**, *Box in a Valise*, 1935–41

23. I would like to thank Michael Taylor for clarifying the intricate details of original and reproduction in Duchamp's "deluxe editions."

24. If pronounced in French the letters read "Elle a chaud au cul," which roughly trans- lates into "she has a hot ass."

Duchamp's critical engagement with original and copy continued to remain an important touchstone for Conceptualists in the 1960s. Man Ray tacitly acknowledged this in his 1967 *The Father of Mona Lisa*. It engages in the kind of double entendre for which Duchamp was famous, and plays with canonical models and references. The title ostensibly refers to the reproduction of a self-portrait by Leonardo da Vinci. Man Ray's insertion of a gleaming cigar in da Vinci's mouth points, however, not so much in the direction of the famous Italian painter of the *Mona Lisa* (1503–6), but the father of the readymade, Marcel Duchamp. Man Ray's work alludes to both Duchamp's use of the readymade and, more specifically, that artist's own notorious print with the title *L.H.O.O.Q.* (1919),[24] a color reproduction of da Vinci's *Mona Lisa* adorned with a fashionable mustache and goatee. Last but not least, Man Ray's cigar may also pay homage to Sigmund Freud, whose theories on the unconscious launched a new scientific discipline and informed the work of Duchamp as well as the many practitioners of Surrealism, a movement to which Duchamp and Man Ray had both made significant contributions.

While Duchamp pioneered the use of editioned boxes, their full implications were recognized in the 1960s when proponents of Fluxus and Conceptual art sought more ephemeral alternatives to the creation of carefully crafted artistic objects. Written directives, photographic reproductions, ephemera, and multiples were all tools meant to help shift the focus from the unique object to the mobility and dissemination of a concept or idea. The term "multiple" came into being in the 1960s when the serial conception of a work enabled artists to seek new channels of distribution, including direct mailing campaigns. In 1968, artist William Copley conceived and financed six portfolios, titled *SMS*, in a spirit of opposition to the traditional gallery system. These editioned sets were mailed directly to subscribers and consisted of compilations of artworks, distributed over the course of a year, by a colorful cast of artists, poets, and performers, including pieces mentioned earlier by On Kawara, Joseph Kosuth, Man Ray, Hannah Weiner, and Lawrence Weiner, as well as works by Marcel Duchamp, John Cage, Dick Higgins, and William Copley himself, among others. Copley's contribution to the fifth portfolio (p. 43) centered on a Chicago barber's battle over copyright issues concerning a monumental public sculpture by Pablo Picasso in the same city, a depiction of which he wanted to retain as his business logo. Copley's piece consists of photographs, press clippings, and letters documenting the controversial copyright debate that allowed Chicago city officials to turn the image of Picasso's sculpture into mass-produced tchochkies such as shirt cuffs and key chain ornaments while placing restrictions on the business owner. Copley's documentation as a whole is a hilarious exercise in the question of original, copy, and commerce, especially since the monumental sculpture was actually built by contractors following a small-scale model by Picasso. Given the genesis of the public sculpture, Copley suggests that Picasso's three-dimensional model (an image of which Copley included in his piece) was in fact a prototype, the finished sculpture and all subsequent commercial adaptations copies of

left: **Man Ray**, *The Father of Mona Lisa*, from No. 3 of the *SMS Portfolio*, 1967
above: **Marcel Duchamp**, *L.H.O.O.Q.*, from *Box in a Valise*, 1935–41

varying degrees.[25] His decision to investigate the commercial dispute over copyright laws in the context of a portfolio that already operates against the notion of the original and its aura may be read as a critique of the fetishistic notion of originality and a credo for the serial strategies that had emerged during the 1960s.

The multiple's potential for greater dissemination also played an important role for Fluxus artists. Its very nature, in its opposition to the unique and precious original, seemed to provide a more affordable alternative to the bourgeois exclusivity and high market value of traditional painting and sculpture.[26] As such it echoed the revolutionary zeitgeist of the 1960s. The growing demand for more accessible and socially relevant art forms, especially in Europe, was reflected in several pioneering shows at that time. Beginning with his 1969 exhibition *When Attitudes Become Form* in Berne, Switzerland, curator Harald Szeemann made a case against the commodification of the arts and challenged artists to find alternatives:

> Artists have shown us that everything can be art. Now they ought to show us that property can be substituted by free activity if in their production they would place less emphasis on art than on action.[27]

In his first proposal for the 1972 Kassel documenta, Szeemann thus proposed a "100 day event," compared to the "100 day museum," a term that had been coined by Arnold Bode, one of the organization's founding members.[28] Although the overall exhibition concept, which called for happenings, performances, ephemeral objects, and conceptual work, changed to include plenty of paintings and sculptures, the ideas of Fluxus, Conceptual, and Performance artists remained central to this influential show, with the artistic practice of Joseph Beuys taking a key position. In his self-prescribed role as teacher, activist, performer, and contributor in a constantly evolving discussion about artistic, social, political, and economic systems, the multiple had great appeal for Beuys. For several years, he had protested the customary enrollment requirements at the Düsseldorf Art Academy, where he was professor of monumental sculpture. He proposed that all applicants should be admitted to the school and he supported student protesters, who utilized his office and the building's hallways as impromptu meeting spaces and studios. This led to his dismissal from the academy in 1974, after which he went on a lecture tour in the United States, with stops at colleges in New York, Chicago, and Minneapolis. In recognition of the major energy crisis occurring at the time, Beuys called his tour "Energy Plan for the Western Man," and elaborated on the necessity of a new social organization in which emphasis was placed on the creative devel-

25. In 1981, Rosalind Krauss unpacked the myth of originality, which Copley addressed in such playful terms nearly two decades earlier. Krauss defined the modernist understanding of the avant garde through its sense of originality, but stressed that copy and repetition were in fact part and parcel of the avant garde from the beginning. See Krauss, "The Originality of the Avant-Garde," in *The Originality of the Avant-Garde*, 151–70.

26. Retrospectively one has to acknowledge that the utopian hopes associated with the multiple during the 1960s were a miscalculation. Although editioned works held the promise of circumventing the commercial network, its distribution could ultimately be managed more effectively by a gallery, thus creating more or different commercial opportunities, not less.

opment of the individual. "The most important production sites," he stated in a later inter-
view, "would not therefore be in industry, producing material goods, but those that produce
purely goods of the mind. Schools, colleges and universities are society's most important
production companies. That is where real capital is formed: ability."[29] During the course of
his lecture tour he created a number of multiples, which emerged out of day-to-day activi-
ties and performances. One of these is his *Noiseless Blackboard Eraser* (1974, p. 15), a felt
eraser used at the New School for Social Research where he had his first public event. It is a
readymade/multiple, a mass-produced object to which Beuys added his signature and with
it a new designation as an object with literal and metaphoric meaning. It is also an implicitly
self-critical piece in as much as it alludes to the constant revision of existing concepts and
models, including his own, which Beuys often illustrated with blackboard presentations.

above: **William Copley**, *The Barber's Shop*, from No. 5 of the *SMS Portfolio*, 1968

27. Harald Szeemann, "Jagd-
partien und Jägerparties:
Böses über den aktuellen
Kunstbetrieb," in Jürgen Harten
and others, *Kunstjahrbuch 1*
(Hannover: Fackelträger Verlag
Schmidt-Küster GmbH; Wien:
Forum Verlag, 1970), 66 (my
translation).

28. See Arnold Bode, "Vorwort
zum documenta-3-Katalog," re-
printed in *Documenta: Idee und
Institutuion. Tendenzen, Konz-
epte, Materialien*, ed. Manfred
Schneckenburger (München:
Bruckmann Pantheon Colleg,
1983), 70–71.

29. A conversation between
Joseph Beuys and Peter Brügge
(May 10, 1984), as quoted in *Jo-
seph Beuys Editions: Collection
Schlegel*, exh. cat., ed. Heiner
Bastian (Edinburgh: Scottish
National Gallery of Modern Art,
1999), 37. The exhibition was
curated by Eugen Blume.

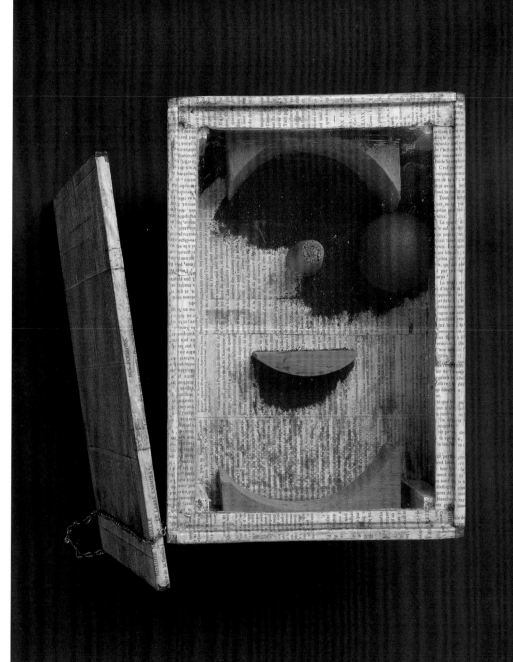

3. Structural Models

Structural models have occupied a special place in artistic production since the early twentieth century, in part because they lend themselves to an exploration of constructs, whether these are fictional realities, the conventions of pictorial representation, or the ways in which real and imagined spaces intersect or collide. Constructive approaches tend to propose alternative, fantastic, or utopian realities. More often than not, however, structural models incorporate deconstructive elements. Beginning with Marcel Duchamp, the use of analog models by artists could be said to be inversed, inasmuch as the assembly of his boxes went hand in hand with a critique or disassembly of existing theoretical models, which were then put forward as models of a different kind—the readymade and the multiple, for instance. Similar processes have been applied by subsequent generations of artists for different ends, whereby the structural model is at times further complicated through photographic representation or schematic renderings.

Within the orbit of Dada and Surrealism, great value was placed on strategies that disrupt a seamless understanding of the rational universe. Dreams, stage sets, games, chance encounters, and the kind of meaningful found objects that could trigger a chain reaction of free association were all welcome elements in creating new visual experiences. Joseph Cornell's assemblage boxes are one example of how the architectural model can productively function in this context and offer viewers an alternative construct of reality, a glimpse into a deeply private and poetic universe. *Untitled* (1940s) is a newspaper-clad

left: **Joseph Cornell**, *Untitled*, 1940s

box covered by a removable lid. It contains several wooden structures, a small amount of loose sand, and a ball that can, at least theoretically, navigate the obstacle course of the interior terrain. Cornell's use of sand in this and other boxes has been considered a reference to the passing of time, as in an hourglass.[30] Indeed the presence of the ball and the newspaper covering the walls of the box can also be seen as temporal markers, while the lid underscores the stage-like effect. The sand in the box introduces a peculiar landscape sensibility which blurs the boundaries between interior and exterior space. The sand can be seen as a shifting signifier referencing a beach, the cyclical rhythms of the tide, a desert landscape, a mindscape, or even the playful setting of a sandbox.

A non-linear relationship between an analog model and a built structure also informs works and environments created by Pop artists and New Realists. Some of the most provocative artistic projects in the 1960s existed only as fantastic models, not necessarily intended to be

above: **Claes Oldenburg**, *Skate Monument*, from *Notes*, 1968

30. See Kynaston McShine, "Introducing Mr. Cornell," in *Joseph Cornell*, ed. Kynaston McShine (New York: The Museum of Modern Art, 1980), 12. McShine also notes that Cornell "believed that the process of distillation and refinement

required to produce his art could not be precisely dated," such that his works often have an approximate date, or no date at all (ibid., 11).

31. As Claes Oldenburg noted himself: "I picked the most crucial intersection I knew, which is where Broadway and Canal Street cross, connecting Long Island with New Jersey and Wall Street to the rest of the country. Also, I've read it's the target

which, according to experts, would be the most efficient in the New York area for a nuclear drop." As quoted in *The Political Arm*, exh. cat. (New York: John Weber Gallery; St. Louis: Washington University Gallery of Art, 1991), 30.

realized, such as Claes Oldenburg's proposal to wedge a gigantic concrete "obstacle monu-ment" at the intersection of Canal and Broadway in Manhattan, or Christo's proposal to clad skyscrapers in downtown Manhattan in tarpaulin and steel cables. Such designs mined the fictional aspects of the architectural model. The infeasibility of such monumental proposals was arguably the point, in Oldenburg's case intended as an ironic anti-war memorial that, if realized, would have crushed the subway below the intersection.[31] Oldenburg's *Notes* (1968), a portfolio of twelve prints, circles around erotically charged objects or themes. "In general," he commented, "this is a suite of 'monuments' which, in my work, may be defined as objects or parts of the body increased to colossal scale and set in a landscape."[32] His *Notes* follow a daydream-like pattern in which obsessive fantasies about inflated and deflat-ed body parts and allusions of violence are turned into proposals for monumental sculpture. "Why should buildings always be boxes?,"[33] is the artist's leading question for the print *Skate Monument* (1968), which combines a Chinese character that doubles as restaurant logo, an upside down caster, a "kneeling" building, and a proposal for a woman's ice skate turned monumental sculpture. In this print the associative chain connects enticing female legs, pedestals, and supports, and with classic (heterosexual) male humor, he proposes the al-luring legs and skirt of a kneeling woman as a potential design for a building. "Bankers," he fantasized, "enter under the canopy of the skirt."[34] Reading the live studio model through the architectural model, as well as the staging of objects in advertisements, and imbuing solid structures with the flexibility and softness of body parts, Oldenburg could be said to facetiously deconstruct all three.

If Oldenburg elevated everyday items to monumental sculptures and public monuments, Edward Ruscha was drawn to existing vernacular structures of little distinction, such as gas stations, apartment buildings, and parking lots. His artist books were carefully arranged compilations of mostly black-and-white images, and served William Jenkins as a crucial reference in his introduction to the exhibition *New Topographics: Photographs of a Man-Altered Landscape*. Writing in 1975, Jenkins made the case for the emergence of a new documentary aesthetic in contemporary art, and considered Ruscha a pioneer of this new "style."[35] This may have been an unintended side-effect, since Ruscha's books first and foremost investigate two rather subliminal models that frame scientific inquiries—the use of non-spectacular black-and-white "documentary" images, and a seemingly factual mode of presentation—in order to turn the concept of objectivity inside out. He achieved this in part by highlighting the fragmentary nature of the photographic image. The flow of images in his enormously long fold-out book *Every Building on the Sunset Strip* (1966)

32. Claes Oldenburg, "Co-ments" from the portfolio *Notes* (1968). As quoted in *Printed Stuff: Prints, Posters and Ephemera by Claes Old-enburg. A Catalogue Raisonné 1958–1996*, ed. Richard H. Axsom and David Platzker (New York: Hudson Hills Press; Madison, WI: Madison Art Center, 1997), 125.

33. Ibid.

34. Ibid., 132. Oldenburg's fantasy is evocative of Niki de Saint Phalle's monumental sculpture *hon–en cathedral (she–a cathedral)* of 1966. This was a gigantic reclining female figure that doubled as an interactive sculpture that visitors could enter by retrac-ing a path traveled at birth. If Oldenburg engages in a play of male fantasy, de Saint Phalle

turns the history of voyeuristic displays of female nudes up-side down and lets the viewer reenter the space of desire, thus emptying it.

35. See William Jenkins, *New Topographics: Photographs of a Man-Altered Landscape*, exh. cat. (Rochester, New York: International Museum of Pho-tography at George Eastman House, 1975).

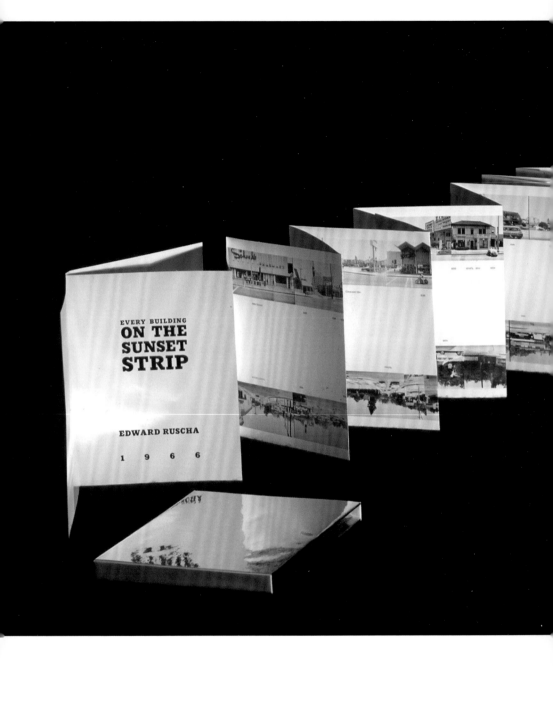

Edward Ruscha, *Every Building on the Sunset Strip*, 1966

left: **Edward Ruscha**, *Parking Lots (May Company, 6150 Laurel Canyon, North Hollywood) #7*, 1967–99
above: **Edward Ruscha**, *Parking Lots (Century City, 1800 Avenue of the Stars) #23*, 1967–99

suggests a seamless documentation of the buildings on the street, but the sequence is ruptured by overlaps and omissions, underscored by the occasionally truncated car. The precise use of addresses below each building and the numerical specificity of Ruscha's book titles further suggest scientific diligence and purpose; the banality of the images and their nondescript subjects aid the articulation of this seemingly scientific rhetoric.[36] Through the fragmentation of a sequence in this and other examples, the books and the images successfully resist narrative interpretation, a strategy that runs counter to the book format as well as the documentary tradition in photography. The model under investigation is thus the rhetoric of scientific exactitude and "facticity" that is associated with documentary photography. Adding yet another twist, Ruscha has recently treated his early artist books as models by isolating individual images for printed editions. This continues the fragmentary

above: Katrin Sigurdardóttir, *Green Grass of Home*, 1997–98

36. Many of Ruscha's book titles emphasize factual numbers: *Twentysix Gasoline Stations* (1963), *Every Building on the Sunset Strip* (1966), and *Thirtyfour Parking Lots in Los Angeles* (1967).

presentation of photographs that began in the 1960s, except with an added layer of geographic dispersal, for each image refers back not only to the site where it was first taken but also to Ruscha's book editions.

If Ruscha's urban topographies complicate a reading of the documentary model, in part by pointing to its inherently fragmentary nature, Katrin Sigurdardóttir ruptures the seamlessness of the landscape through the realignment of the model's topography. At once container and display, her foldable structures rely on both analog and conceptual uses of the model in order to create a compelling new vision. The landscape sections in her suitcase containers are compartmentalized and fold out into irregular patchworks that emphasize the fragmentary nature of her arrangements. In *Green Grass of Home* (1997–98), parks and nature preserves from her native Reykjavik are juxtaposed to others from San Francisco, Berkeley, and New York City, places where she has lived or visited. "Home" is an emotionally charged term that can apply to one's abode, neighborhood, country, or place of personal significance. Sigurdardóttir multiplies and fractures the meaning of the term, reflecting at once on a personal journey and the growing social and economic reality of people moving from place to place. With every new destination, past homes become history and as such part of personal memory. If maps are commonly used as analog tools meant for navigation, Sigurdardóttir's three-dimensional topographies are constructed from memory and chart a course of emotional affinities. Space here is not conceived as one continuous, logical expanse but as a series of significant sites to which the artist's topographic model confers a kind of proximity and mobility that parallels the structure of memory. It is appropriate then, that the artist uses incongruous scales in different topographic compartments—lengthens or shortens a stretch of land, or bestows a different scale upon a feature within it. There is a circular logic to this work where the static display of the model acts as the stage for an exercise in mobility, referencing the art object, which travels from one exhibition venue to another, a person's physical journey from place to place, and the ability of human memory to connect places that are geographically remote. All of these braid here into one coherent yet fragmentary tapestry.

At the heart of Thomas Demand's work sits the recognition that photography operates as a silent accomplice in the writing of history.[37] His photographs hinge on a critical examination of photographic representation and the analog model in order to rupture both from within. They depict carefully staged, life-size paper models, which he constructs based on images from the mass media or history books. In other words, Demand creates photographs of great immediacy that are in fact the result of a threefold process of removal from an actual event. The innocuous stacks of paper in *Pile* (2001) are close-ups of the Florida paper ballots that

37. For a more detailed discussion of Demand's associative use of photography compared to its descriptive and illustrative function in his-torical writing, see my essay "Staging History" in a 2007 forthcoming issue of *History of Photography* dedicated to the subject of hybridization.

53

were recounted in the contested American presidential election of 2000. Many of his images hinge on this kind of pivotal political or historical event, but potentially recognizable images are estranged through close-ups, a change in perspective, and the elimination of protagonists. Demand's photographs register at first as purely formal, aesthetic exercises, and one feels fooled retrospectively by their sleek appearance.

Built into each photograph are clues to the fact that the depicted scene is a paper model, an artificial construct. Paper edges, creases, and other details speak about the materiality of the paper model and the process of its making. One might say this staging of artifice is merely Demand's artistic method, for the journey of reconstruction that begins with the recognition that one is looking at a paper maquette leads not in one but many directions. Unlike other artists working in this arena, he eliminates the recognizability of the model, which would be the essence of a readymade. Demand's method is based on vague association rather than recognition. This is possible because the artist's model is not limited to one image but operates through a play with pictorial genres or styles that are not immediately apparent. If Ruscha demonstrated that "documentary photography" is a rhetorical style associated with scientific accuracy, one that bestows an aura of exactitude if not authority, Demand shows that each new image is read through the matrix of existing pictorial models, including documentary images, artistic and architectural styles, and more subliminal aesthetic codes communicated through movies, advertisements, and other ephemera. In place of the "original," or the representation of the original, the viewer is confronted with the interpenetration of endless references that constantly blur the line between the objective and subjective, between fact and fiction. Ultimately, one is compelled to read Demand's photographs as an exploration of our relation to the photographic image, historic narrative, and importantly, the chain of associations generated by personal memory.

Mark Bennett's "architectural renderings" from the 1990s are reconstructions and center on television series that first aired in the 1950s and '60s. Series such as *The Honeymooners*, *Gilligan's Island*, and *Batman* did much to articulate social stereotypes and narrative clichés. By his own account Bennett was fascinated with television sitcoms and series, and began drawing the stage sets when he was still a teenager; his work operates at a juncture where actual and imagined spaces collide. The incompleteness of his architectural rendering of *Ralph and Alice Kramden's residence (The Honeymooners)* (p. 12) succinctly articulates this gap. In Bennett's rendering, the home consists of a single room, the kitchen. The door to the bedroom leads into a void since the camera never reveals what lies behind that door. Likewise, the bathroom and hallway are off-limits. The artist titles his schematic layout "Home of Ralph and Alice Kramden," followed by a street address, as if the people and apartment actually existed in the city of Brooklyn rather than in a virtual reality.

If the Kramden apartment layout articulates the fragmentary nature of the stage set in the simplest terms, Bennett's visual interpretation of Batman's Wayne Manor goes into elaborate detail, rationalizing a seemingly cavernous estate. Despite the artist's apparent intentions to create a coherent architectural plan, incongruities gradually emerge. There is haphazardness in the adjacency of rooms and incompatibility of portions of the upper and lower floors, not to mention the eclectic layout of the overall "building;" all of this reflects the ongoing evolution of the movie script rather than an architectural master plan. Compared to the specificity of the address given for the Kramden home, the location of the Batman residence is more circumspectly labeled "Gotham City," a nickname for New York City dating back to the nineteenth century. The gap between the specificity of the rendering and the vagueness of the supposed location becomes even greater when considering Gilligan's Island, somewhere in the Pacific Ocean. In this case the artist turned different television sets into a coherent and unified topology, replete with palm trees and a complete coastline. Bennett has entertained the possibility that people might use his blueprints as prototypes for building their homes, and fantasized "about building a utopian neighborhood, where instead of a Spanish villa or ranch house, you could choose a Mike & Carol Brady or a Darrin & Samantha Stevens to live in."[38] In as much as the dream of home-ownership is a central feature of the American pursuit of happiness, it is intimately linked to one's identity and taste. To select a future home design based on a favorite television series would seem to fully embrace and recast the simulacrum as real.

left: **Thomas Demand**, *Pile*, 2001

38. Mark Bennett, *TV Sets: Fantasy Blueprints of Classic TV Homes* (New York: TV Books, 1996), xi.

HOME OF: BRUCE WAYNE & DICK GRAYSON
WAYNE MANOR
GOTHAM CITY

GILLIGAN'S ISLAND
PACIFIC OCEAN

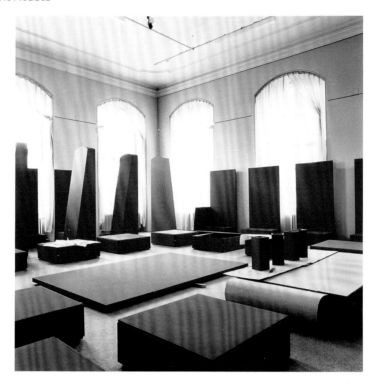

Both Candida Höfer and Isa Genzken engage the rhetoric of architectural space as a model for critique. Höfer's photographs are carefully calibrated compositions of institutional interiors such as libraries or museums, as repositories of knowledge and learning. The artist's eye carefully records the dialectic between architectural interiors and the content they frame. As an institutional entity, the ethnographic museum has become particularly problematic insofar as it involves the re-contextualization of behavior, customs, rituals, and artifacts that are meant for use, rather than for aesthetic contemplation. More importantly, this re-contextualization has typically been conducted by and for members of a different culture. In Höfer's *Museum of Ethnography Dresden I* (*Museum für Völkerkunde Dresden I*; 1999), the absence of artifacts sets up an incongruous relationship between the freshly painted, ultra-modern display furniture and the artifacts for which they are intended. The artist suggestively posits the display furniture as anthropological artifacts, offering a glimpse into our own customs and rituals. If Höfer makes beautifully designed interiors the center of her investigation, Isa Genzken often articulates a critique of the fetishistic stylization of objects through structures that mimic the architectural model. Reminiscent of skyscrapers, the slapdash execution of her glittering towers upsets the modernist

left, top: **Mark Bennett**, *Home of Bruce Wayne and Dick Grayson (Batman)*, 1997
left, bottom: **Mark Bennett**, *Gilligan's Island*, 1995
above: **Candida Höfer**, *Museum für Völkerkunde Dresden I* (*Museum of Ethnography Dresden I*), 1999

preoccupation with elegant line and harmony and works in opposition to notions of structural soundness. Yet beyond the critique of an aesthetic model seems to lie a deeper concern with social and political questions. The mirrored surfaces that alternate with garishly colored, opaque ones in Genzken's *Little Crazy Column* (2002) and *Bill II* (2001, p. 6) reflect and fracture the viewer, suggesting that the contemporary urban experience renders the individual itself a fragment or fleeting pixel. Through the use of the architectural model Genzken implicitly questions modernist idealism and posits a far more complex and fragmentary notion of individuals and their environment.

If conceptual models allow for playful experimentation with creative possibilities, their inner structure and scope also determines their limits, comparable perhaps to a game of chess. Their successful function as propositions relies on the viewer's willingness to engage with and accept their underlying logic. With the 1960s came a greater sensitivity toward the conceptual ordering principles and structures that obliquely form and inform the ways we catalogue information, analyze, think, and act. The many applications of structural models by artists in the last decades demonstrate that a complication of the linear relationship between reality and the built model can generate new meanings, critical questions, and poetic possibilities.

Let me conclude this discussion by expanding the parameters of the exhibition to point to two additional contemporary artists who have further developed the logic of the model. Andrea Zittel's modular *A-Z Living Units* (1993-94) are models for efficient living on the smallest possible scale. In her work, the rigidity of the conceptual model can not only be imagined but inhabited. And in the unlimited editions of Felix Gonzalez-Torres' work, the multiple has been taken to an entirely new level. His installations are ephemeral: they briefly take shape in an exhibition (a stack of posters, a floor covered in candy) before the individual objects go into circulation by leaving the museum with the visitors. In this case, the total dispersal of the installation marks its own ephemerality and becomes the defining concept of the work.

What emerges from this survey, then, is the notion that the fundamental characteristics of the model—its artificiality and constructedness—lend themselves to the formulation of alternative or fictional realities as well as to critical engagement with constructs of reality, their representations, or other framing conditions. Models can serve as models for experimentation and critique, and as such they promise to remain a rich territory for future artistic experiments.

Catharina Manchanda

right: Isa Genzken, *Little Crazy Column*, 2002

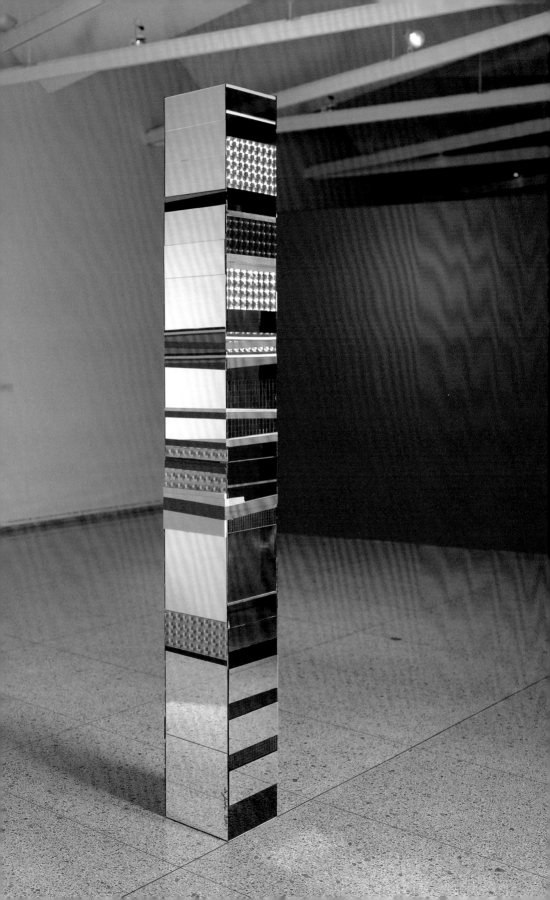

60

Mark Bennett
Gilligan's Island, 1995
Lithograph, ed. 10, 24 1/2 x 36 1/4"
Courtesy of the artist and the Mark Moore Gallery,
Los Angeles
Ill. p. 56

Mark Bennett
Home of Ralph and Alice Kramden (The Honeymooners), 1995
Lithograph, ed. 10, 24 1/4 x 36 1/4"
Courtesy of the artist and the Mark Moore Gallery,
Los Angeles
Ill. p. 12

Mark Bennett
Home of Bruce Wayne and Dick Grayson (Batman), 1997
Lithograph, ed. 50, 32 x 48"
Courtesy of the artist and the Mark Moore Gallery,
Los Angeles
Ill. p. 56

Joseph Beuys
Noiseless Blackboard Eraser, 1974
Felt blackboard eraser, 102/550, 1 x 2 1/16 x 5 1/4"
Mildred Lane Kemper Art Museum, Washington University
in St. Louis, gift of Ronald and Frayda Feldman, 1990
© 2006 Artists Rights Society (ARS), New York /
VG Bild-Kunst, Bonn
Ill. p. 15

Max Bill
16 Constellations, 1974
Portfolio of 16 color lithographs, 4/25, 20 x 14" each
Mildred Lane Kemper Art Museum, Washington University
in St. Louis, gift of Arthur and Sheila Prensky, 2004
© 2006 Artists Rights Society (ARS), New York /
ProLitteris, Zürich
Ill. p. 23

Daniel Buren
Twenty-five Enamel Plates, 1993
25 pieces of steel enameled in two colors, ed. 15,
17 1/8 x 17 1/8" each
Mildred Lane Kemper Art Museum, Washington University
in St. Louis, University purchase, Parsons Fund, 2005
© 2006 Artists Rights Society (ARS), New York / ADAGP,
Paris
Ill. pp. 32–33

William Copley
The Barber's Shop, from No. 5 of the *SMS Portfolio*,
1968
Mixed media, ed. 40, 10 x 6 13/16"
Mildred Lane Kemper Art Museum, Washington University
in St. Louis, University purchase, 1990
Ill. p. 43

Le Corbusier
Le Modulor, 1956
Lithograph, 28 7/8 x 21 3/8"
Mildred Lane Kemper Art Museum, Washington University
in St. Louis, University acquisition, 1962
Ill. p. 10

Joseph Cornell
Untitled, 1940s
Wood, metal, paper, paint, glass, smalt, and rubber,
11 1/2 x 7 7/8 x 3 5/16" (closed)
Collection of the Saint Louis Art Museum, gift of The Joseph
and Robert Cornell Memorial Foundation 214:1996
Art © The Robert and Joseph Cornell Memorial Foundation /
Licensed by VAGA, New York
Ill. p. 44

Thomas Demand
Pile, 2001
Two Lambda prints, 33/35, 17 x 22 1/2" and 20 x 19"
Collection of Nancy Reynolds and Dwyer Brown
Photo courtesy of Barbara Krakow Gallery, Boston
© 2006 Artists Rights Society (ARS), New York /
VG Bild-Kunst, Bonn
Ill. p. 54

Marcel Duchamp

Pocket Chess Set, 1944
Leather case with plastic pieces, ed. 25,
6 ¹/₂ x 8 ⁵/₈ x ³/₈" (open)
Mildred Lane Kemper Art Museum, Washington University
in St. Louis, gift of the Betty Parsons Foundation, 1985
© 2006 Artists Right Society (ARS), New York / ADAGP,
Paris / Succession Marcel Duchamp
Ill. p. 36

Isa Genzken

Bill II, 2001
Reflective glass, holographic foil, and paper on fiberboard
support, 110 ¹/₄ x 12 ³/₁₆ x 12 ³/₁₆"
Mildred Lane Kemper Art Museum, Washington University
in St. Louis, University purchase, Charles H. Yalem Art Fund,
2003
Ill. p. 6

Isa Genzken

Little Crazy Column, 2002
Reflective glass and holographic foil on fiberboard support,
102 ³/₈ x 12 ³/₁₆ x 12 ³/₁₆"
Mildred Lane Kemper Art Museum, Washington University
in St. Louis, University purchase, Charles H. Yalem Art Fund,
2003
Ill. p. 59

Candida Höfer

Museum für Völkerkunde Dresden I (*Museum of
Ethnography Dresden I*), 1999
C-print, 47 ¹/₄ x 47 ¹/₄"
Mildred Lane Kemper Art Museum, Washington University in
St. Louis, University purchase with funds from Mr. and Mrs.
Richard K. Weil, Morton D. May, and the bequest of Jane G.
Stein, by exchange, 2002
© 2006 Artists Rights Society (ARS), New York /
VG Bild-Kunst, Bonn
Ill. p. 57

Jenny Holzer

Selections from "The Survival Series," 1983–84
Electronic LED sign with yellow diodes, 2/4,
6 ¹/₂ x 60 ³/₄ x 4"
Mildred Lane Kemper Art Museum, Washington University
in St. Louis, University purchase, Charles H. Yalem Art Fund,
1991
© 2006 Jenny Holzer, member Artists Rights Society (ARS),
New York
Ill. p. 35

Alfred Jensen

Great Mystery I [Chinese Origin of the Decimal
System! External Placement.], 1960
Mixed media on canvas, 50 x 42"
Mildred Lane Kemper Art Museum, Washington University
in St. Louis, gift of Mr. and Mrs. Richard K. Weil, 1963
© 2006 Estate of Alfred Jensen/Artists Rights Society
(ARS), New York
Ill. p. 19

Wassily Kandinsky

Selections from the *Kleine Welten* (*Small Worlds*)
series, 1922
Kleine Welten I
Lithograph, 14 x 11"
Kleine Welten II
Lithograph, 13 ¹/₂ x 11 ¹/₈"
Kleine Welten III
Lithograph, 14 x 11"
Kleine Welten IV
Lithograph, 13 ¹/₂ x 11 ¹/₂"
Kleine Welten V
Woodcut, 14 x 11"
Kleine Welten VII
Woodcut, 14 ¹/₈ x 11 ¹/₄"
Mildred Lane Kemper Art Museum, Washington University
in St. Louis, University purchase, Plant Replacement Fund,
1964
© 2006 Artists Rights Society (ARS), New York /
ADAGP, Paris
Ill. p. 16

On Kawara
100 Year Calendar, from No. 4 of the *SMS Portfolio*, 1968
Offset print on paper, ed. 40, 20 x 37 ³/₄"
Mildred Lane Kemper Art Museum, Washington University in St. Louis, University purchase, 1990
Ill. p. 31

Joseph Kosuth
Four Titled Abstracts, from No. 3 of the *SMS Portfolio*, 1968
Offset print on paper, ed. 40, 20 x 20" each
Mildred Lane Kemper Art Museum, Washington University in St. Louis, University purchase, 1990
© 2006 Joseph Kosuth/Artists Rights Society (ARS), New York
Ill. pp. 24–25

Man Ray
The Father of Mona Lisa, from No. 3 of the S*MS Portfolio*, 1967
Offset print on paper, ed. 40, 10 ⁵/₈ x 6 ⁷/₈"
Mildred Lane Kemper Art Museum, Washington University in St. Louis, University purchase, 1990
© Man Ray Trust / Artists Rights Society (ARS), New York / ADAGP, Paris
Ill. p. 40

Claes Oldenburg
Skate Monument, from *Notes*, 1968
Lithograph, 39/100, 22 ³/₄ x 15 ³/₄"
Mildred Lane Kemper Art Museum, Washington University in St. Louis, gift of Arthur and Sheila Prensky, 1984
Ill. p. 46

Edward Ruscha
Every Building on the Sunset Strip, 1966
Artist book, black offset print on paper, folded and glued, 7 ¹/₁₆" x 5 ⁵/₈ x ³/₈" (closed)
Collection of the Washington University Art & Architecture Library, St. Louis
© Ed Ruscha. Courtesy Gagosian Gallery, New York
Ill. cover, pp. 48–49

Edward Ruscha
Parking Lots (Century City, 1800 Avenue of the Stars) #23, 1967–99
Gelatin silver print, 9/35, 14 ⁷/₈ x 14 ⁷/₈"
Mildred Lane Kemper Art Museum, Washington University in St. Louis, University purchase, Charles H. Yalem Art Fund, 2000
Ill. p. 51

Edward Ruscha
Parking Lots (May Company, 6150 Laurel Canyon, North Hollywood) #7, 1967–99
Gelatin silver print, 10/35, 14 ⁷/₈ x 14 ⁷/₈"
Mildred Lane Kemper Art Museum, Washington University in St. Louis, University purchase, Charles H. Yalem Art Fund, 2000
Ill. p. 50

Katrín Sigurdardóttir
Green Grass of Home, 1997–98
Mixed media, dimensions variable
Collection of the Reykjavik Art Museum
Ill. p. 52

Hannah Weiner
Signal Flag Poems, from No. 3 of the *SMS Portfolio*, 1968
Offset print on paper, ed. 40, 7 ³/₄ x 6 ³/₄"
Mildred Lane Kemper Art Museum, Washington University in St. Louis, University purchase, 1990
Ill. pp. 28–29

Lawrence Weiner
Turf, Stake and String, from No. 5 of the *SMS Portfolio*, 1968
Offset print on mylar decal, ed. 40, 6 ¹/₄ x 8 ⁵/₈"
Mildred Lane Kemper Art Museum, Washington University in St. Louis, University purchase, 1990
© 2006 Lawrence Weiner / Artists Rights Society (ARS), New York
Ill. p. 26

Marcel Duchamp

L.H.O.O.Q., replica of 1919 assisted readymade,
from *Box in a Valise*, 1935–41
Philadelphia Museum of Art: The Louise and Walter
Arensberg Collection, 1950
© 2006 Artists Rights Society (ARS), New York / ADAGP,
Paris / Succession Marcel Duchamp
Ill. p. 41

Marcel Duchamp

Box in a Valise, 1935–41
Leather valise containing miniature replicas, photographs,
and color reproductions, 16 x 14 $^3/_4$ x 4 $^1/_2$" (closed)
Philadelphia Museum of Art: The Louise and Walter
Arensberg Collection, 1950
© 2006 Artists Rights Society (ARS), New York / ADAGP,
Paris / Succession Marcel Duchamp
Ill. p. 38

On Kawara

Dec. 14, 2004, 2004, from the *Today Series*, 1966–
Acrylic on canvas, 10 x 13 $^1/_2$"
KAWON0182
Photo courtesy David Zwinner, New York
Ill. p. 34